The

When he isn't being a conspiracy theorist,
Ron Wood is a parish priest and a cartoonist
for the *Church Times*.

The St Gargoyle's Code

*How many hidden meanings
can you find?*

Ron Wood

CANTERBURY
PRESS
Norwich

© Ron Wood 2006

First published in 2006 by the Canterbury Press Norwich
(a publishing imprint of Hymns Ancient & Modern
Limited, a registered charity)
9–17 St Alban's Place, London
N1 0NX

www.scm-canterburypress.co.uk

British Library Cataloguing in Publication data

A catalogue record for this book is available
from the British Library

ISBN 1-85311-760 9/978-1 85311 760 2

Typeset by Regent Typesetting, London
Printed and bound by
Bookmarque, Croydon, Surrey

Introduction

If you search these little drawings carefully, who knows what arcane symbols, subversive messages and hidden geometry you will find? Lots of people, including those nice men and women at Canterbury Press, have already tried taking the first letter of each caption, and making an anagram of the result. Or you could try looking for a Fibonacci sequence, if you know what one is, which I don't. (Very likely they told us at school one day when I was off sick, or pretending to be, anyway.) Even otherwise sensible people are still looking for meanings when there are none. You know the sort of earnest chaps in seventies tank-tops who come up to you at parties with a fistful of Twiglets and a glass of something non-alcoholic and say: 'Your cartoons really give me food for thought'? Oh dear. Unless what passes for my brain is doing something subliminal, the only thing I'm trying to do is make people laugh.

Many people (well, somebody did once), have asked me where I get my ideas from. Roughly once a month, panic sets in, because I'm expected to send something to the *Church Times*

and I haven't a clue what. So I suck the end of my pen, think back to what has happened in church over the last month, and draw it. Just like that. Even though Canterbury Press is always saying it's fantasy, trust me, it isn't. Reality in the Church of England is always funnier then I could make up. Real events and real people are shown here. A few names, faces, church furniture, and other unimportant details might get changed. Maybe I do make some things up, but don't worry about it – just enjoy what is, after all, a little book of cartoons – or *is that just what they want you to think?*

Ron Wood

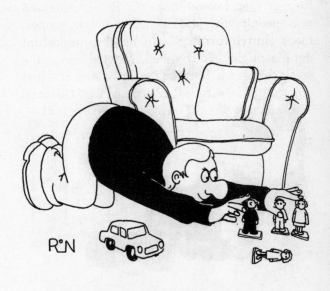

'OK,' said the PCC, 'We'll double your expenses, and you can have every other Sunday off.'

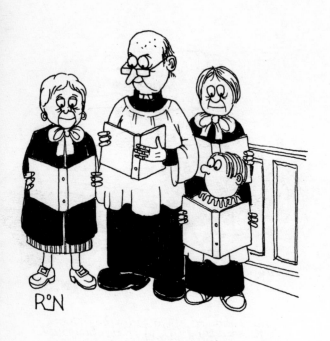

*After hours of rehearsal, the choir was
ready to perform the 'Messiah'.*

*Gary showed his faith by the fish on
the back of his car.*

*Lawrence believed his invention would
revolutionise church music.*

Dennis had been ordained fairly young.

*This year's Advent wreath promised
to be something special.*

The new windows at the vicarage
proved an unexpected hazard.

*Taking out the pews only half
solved the problem.*

When boredom set in, they played
'Mr Tambourine Man'.

*Clarence put in a plea for a
little less starch.*

*Jennifer decided that next week she
would wear sandals.*

*Roger invented a whole new season,
just so that he could wear turquoise.*

*Afterwards, they nipped round
the corner for a crafty smile.*

*When the call came, Desmond
would be ready . . .*

*Louise tried to explain about the
Church hoover and the Christmas tree.*

The choir were forced to give up
their weapons of mass disruption.

*Everyone at the vicarage was
expected to make economies.*

*. . . and to think people had laughed
at Len, hoarding all the candle ends.*

*Nobody was going home until the
culprit confessed.*

The bishop wished he'd never agreed to bless a jumbo jet.

*Everyone noticed the vicar's
two short planks.*

*Dennis always knew when his
friend was unhappy.*

*Under the vestry rug they found
the remains of a lost
civilization.*

Brian never could remember the difference between a thurible and a chasuble.

The heatwave affected the Anglo-Catholics more than most.

The overhead projector offered great opportunities for modern evangelism and old-fashioned messing about.

*The churchyard working party
reported back.*

They obtained fine rubbings of Sir Hugh le Paunce and Mrs Blewitt.

. . . on the subject of gay clergy, Steve refused to be drawn.

*Will was looking for the
seminar on 'Understanding Islam'.*

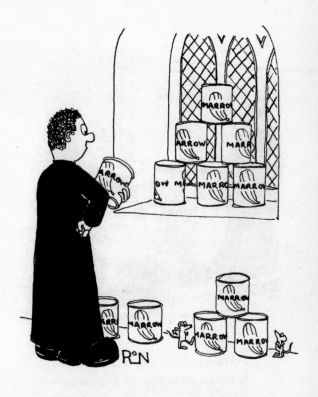

*There was a good response to the
appeal for tinned produce.*

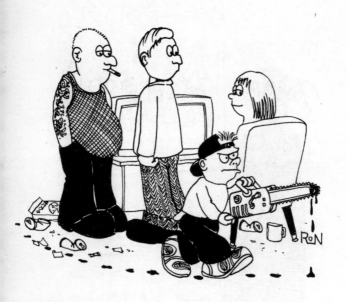

*Michael wondered if little
Wayne was ready for baptism.*

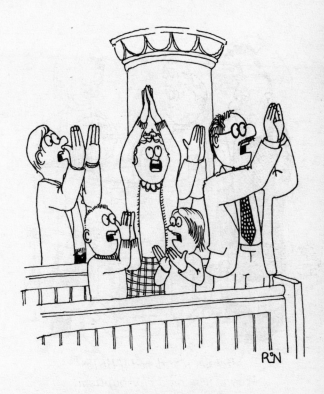

*Unusually for the time of year, there
was a plague of midges.*

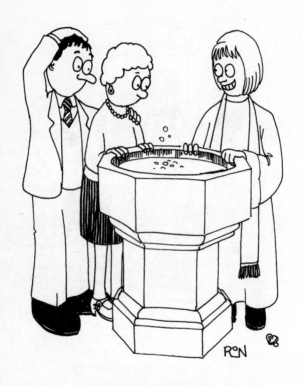

*Somehow, saying 'Whoops' didn't
seem to be enough.*

*While he tried to remember
his message, the little chap
made himself useful.*

*Work on the escape tunnel continued under
cover of the bishop.*

'Bless you,' muttered Barry.

The Vanpoulle's Pocket Pulpit
was not a great success.

Newcomers were made especially welcome.

*The vicar would always welcome
new people moving into the parish.*

The sisters took their meals in silence.

*Mark asked the organist if he could
give the last hymn more of a 'rock' feel.*

There was no mistake – it was the rare
1937 People's Plain.

Melanie won gold in the all-comers
(stained glass) category.

Everyone heard all about Steve's silent retreat.

*The whole cast came back for yet another
curtain call.*

He spoke of his vision of the Kingdom in the parish, and the state of the hoover.

*You could always tell who had done
the seminar on juggling.*

The Paras' chaplain came in for some light-hearted teasing.

The choir sang no. 67 from The Hip-and-Thigh Psalter.

Tony experienced the seven-year itch.

Shirley's husband was a great supporter of church bazaars.

*The Alpha Course was a huge success
in Bishops Wibbling.*

*Michael cursed the cartoonist for
not drawing in the steps.*

*The trainspotters wouldn't sing hymns
but they wrote down the numbers.*

*Another day with drunks, dropouts and
deadbeats – how he hated Clergy Chapter!*

The churchwardens made sure that
Mattins was used at least once a month.

The jumble sale always attracted an enthusiastic crowd.

*The prayer group just lifted
Mary's knees to the Lord.*

*They were a small congregation, but
full of enthusiasm.*

*After the Resolution from Lambeth, Bishop
Ivan tidied his sock drawer.*

*At last the restoration was finished, and
the scaffolding had come down.*

Dennis decided to wear something black.

'Meekly kneeling upon your knees',
he repeated with heavy emphasis.

If they'd told her about the heating grille once, they'd told her a hundred times.

*When Harry's stole caught fire,
it was a while before anyone
noticed.*

*The Revd Julian Vanpool-Smoddle
already 'dressed down' as much as
he could.*

*The English Folk Mass made a
real impact on Robert.*

When he preached a sermon with more than three points, Derek's congregation snapped.

Halfway down the aisle, Eric had a puncture.

*The new organ was much larger than
the old one.*

*Carol invited the children to bring their
teddies for a blessing.*

*The rumour of a teenager in church
turned out to be true.*

The diehard fans were at the back, playing air organ.

The Revd Claude Badleigh even wore pants of the correct liturgical colour.

*Melanie was delighted that Frank was
able to unblock the font.*

The One Ring fell into the hands of the choirmaster.

*Desperate to attract Percy, Helen
put incense behind her ears.*

*Visiting preachers were allowed
twenty minutes.*

*The wind changed, and Jim was stuck
like it.*

'The Manichaeians practised asceticism
because they believed matter itself is
inherently evil,' added Desmond.

*Diane asked Synod to suspend Standing
Orders so the visitor could speak.*

Brian realised with horror he would have to re-do the cleaning rota from scratch.

*. . . and there they found him, the clerical
outfitter's catalogue still open at the page
of bras.*

*As George got older, Evensong seemed
to take longer and longer.*

*By a strange coincidence, the concelebrants
were Angus Day and Gloria Inexcelsis.*

For his spiritual exercises, Frank used the Anglican cycle of prayer.

The organ-tuner's laughter echoed round the church.

*There was always someone trying
to beat the system.*

'If this is cell church,' mused Harold,
'you can keep it.'

*The twelfth-century corbels represented
the sins of the flesh.*

Peter stumbled across the Wippels'
catalogue photo-shoot.

*The bishop's grandsons always
enjoyed their visits.*

*Everybody thought theirs was the
most original sin.*

Aunt Hilda had knitted Andrew another chasuble.

*Mrs Rogers was convinced her
toaster was possessed.*

Maurice was greatly encouraged by the feedback from his sermons.

*The traditionalists were planning
to infiltrate the PCC.*

*It was feared that if girls joined
the choir, the boys would leave.*

*Stephen found out he was older than the
Archbishop of Canterbury.*

*Leo's talk on the history of votive
candles was lavishly illustrated
with slides.*

Heather was delighted that her sermon opened up a vigorous debate.

Geoffrey's wife told callers
he was away on a course.

*Any excuse for a Service of Blessing
was seized upon.*

*Suddenly, everyone wanted to
be excused at once.*

Nobody ever saw Dennis without his dog-collar.

*He explained what was meant
by extended communion.*

'What's so special about women's
spirituality?' wondered Michael.

As the sermon passed fifteen minutes,
the Archers fans showed signs of panic.

It was another routine day at the pets' cemetery.

*A crack squad of Mothers' Union
activists struck, and left a sponge.*

*Religious tolerance was not
Martin's strong point.*

*Rupert realised it was true – the clerical
collar did open doors.*

Anything was worth a try . . .

*The vicar was always a welcome
visitor at playschool.*

*The archdeacon set off to install
the new vicar of St Ethels.*

*The Revd Hugo Next had his first
tiny inkling that something had
gone terribly wrong.*

She first began to suspect when
he came home smelling of tambourines.

The parish was about to enter
a new era . . .

*David showed Doris the celebrated
Bishops' Garden.*

*In an evangelical parish, incense
is a solitary pleasure.*

The curate called it waiting on the Lord.
The vicar called it skiving.